Jacqueline
Cl

NOBLE BEINGS

SPIRITUAL HANDBOOK

FOR CHILDREN (OF ALL AGES)

♡ Love
Joeli.

For the Children.

Who are,

Who forever abide within us,

Who will be.

"One righteous act...can tear every bond asunder..."

"Whoso ariseth, in this Day...and summoneth to his assistance the hosts of a praiseworthy character and upright conduct, the influence flowing from such an action will, most certainly, be diffused throughout the whole world." - Bahá'u'lláh

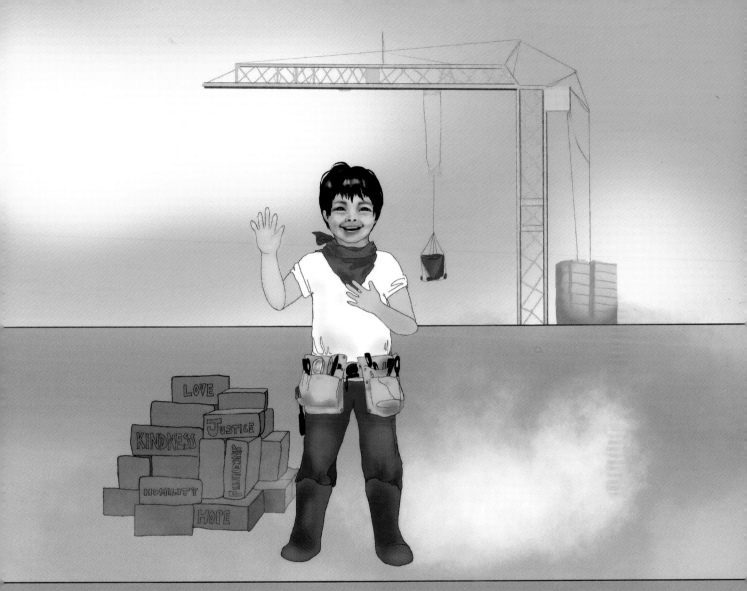

TRUTHFULNESS

is the foundation of all human virtues.

To give and to be generous are attributes of Mine...

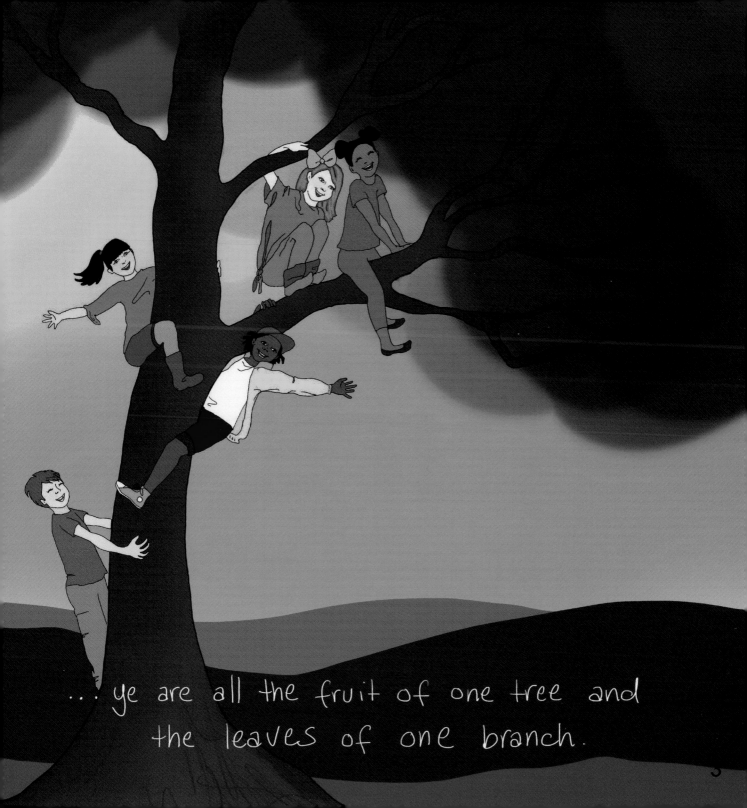

... ye are all the fruit of one tree and the leaves of one branch.

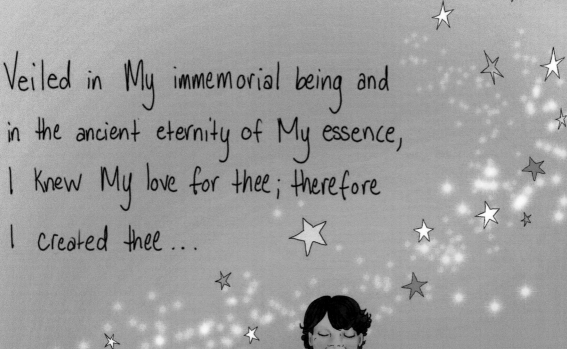

Veiled in My immemorial being and
in the ancient eternity of My essence,
I knew My love for thee; therefore
I created thee...

With the hands of power I made thee and with the fingers of strength
I created thee; and within thee have I placed the essence of My light.
Be thou content with it and seek naught else, for My work is perfect...

Thou art My lamp and My light is in thee.

Regard man as a mine rich in gems of inestimable value.
Education can, alone, cause it to reveal its treasures...

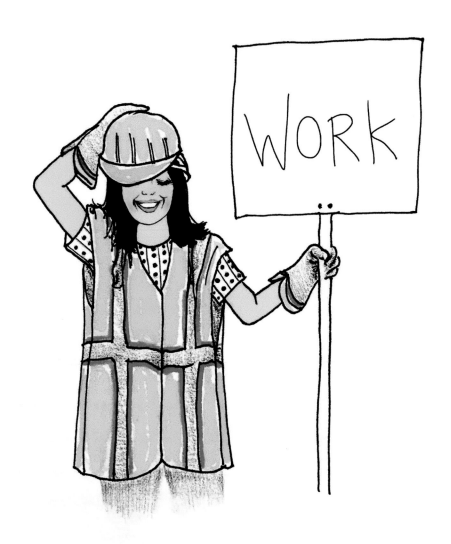

done in the spirit of service
is the highest form of worship.

... courtesy ... is the prince of virtues.

... let your heart burn with loving kindness
for all who may cross your path.

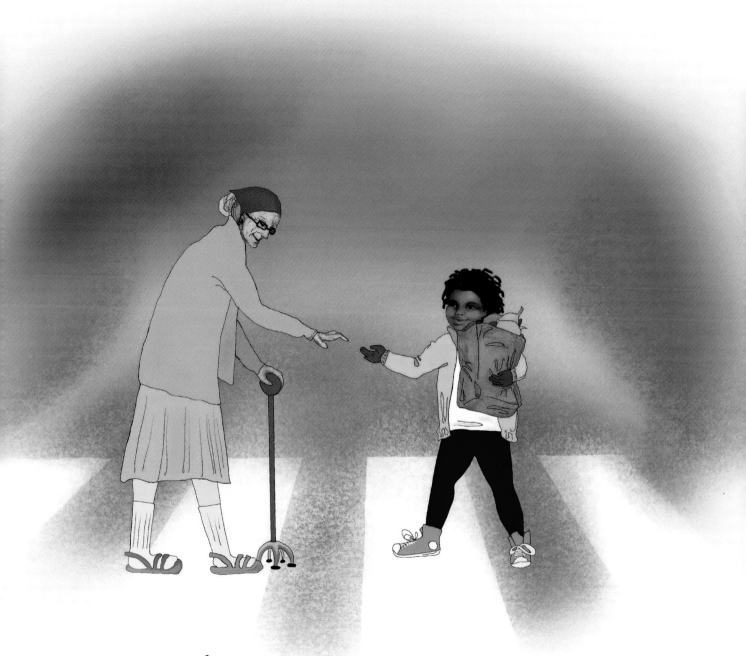

The betterment of the world
can be accomplished through pure and goodly deeds...

... strive that your actions day by day
may be beautiful prayers.

Noble have I created thee...

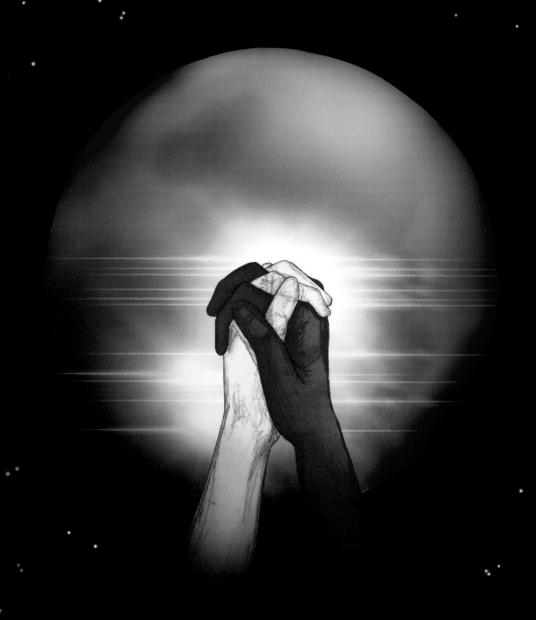

So powerful is the light of unity
that it can illuminate the whole earth.

Love
is heaven's
kindly
light

If it be Thy pleasure, make me to grow
as a tender herb in the meadows of Thy grace...

A thought of hatred must be destroyed
by a more powerful thought of love.

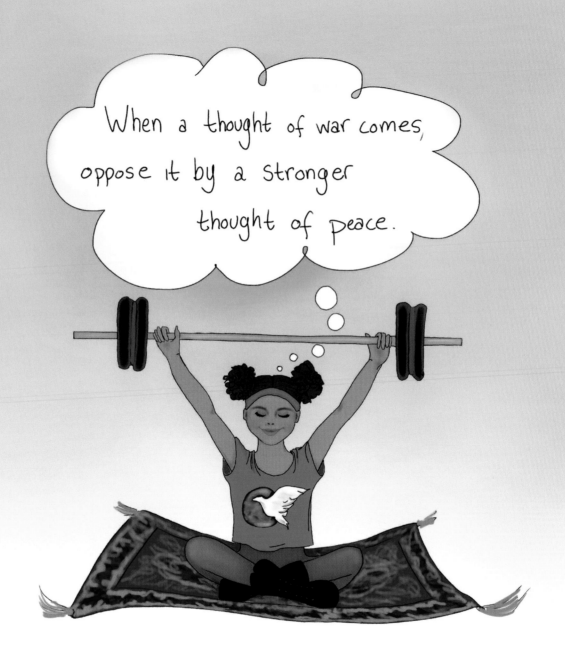

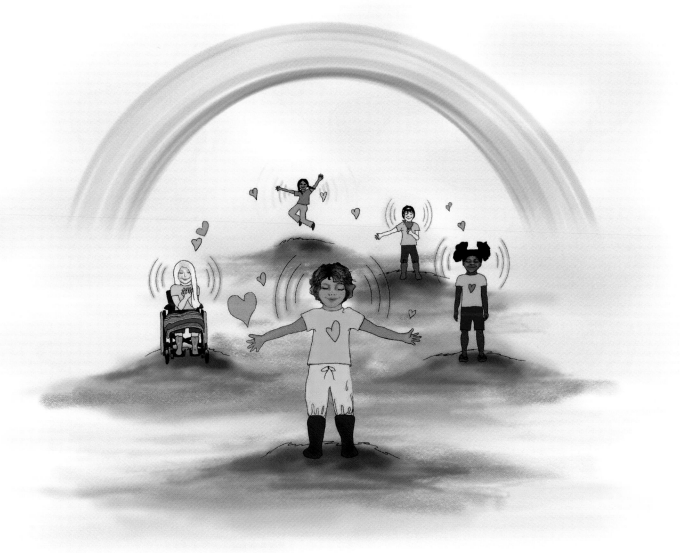

If you desire with all your heart, friendship with every race on earth,

your thought, spiritual and positive, will spread; it will become the desire of others,

growing stronger and stronger, until it reaches the minds of all men.

The more detached and the purer the prayer,
the more acceptable is it in the presence of God.

Work steadily. Sincerity and love will conquer hate.

Let your vision be world-embracing,
rather than confined to your own self.

22

. . . love all the world . . .

I will no longer be sorrowful and grieved;
I will be a happy and joyful being.

Jealosy consumeth the body and anger doth burn the liver:
avoid these two as you would a lion.

Bestow upon me a pure heart,
like unto a pearl.

Joy gives us wings!

O God, my God,
my Beloved,
my heart's Desire.

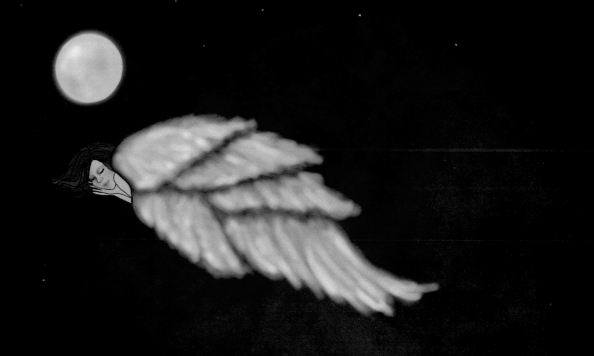

'Neath the shade of
Thy protecting wings let me nestle...

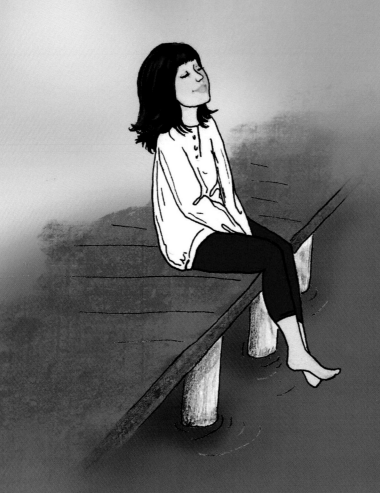

Be patient under all conditions,
and place your whole trust and confidence in God.

Our shortcomings are many, but
the ocean of Thy forgiveness is boundless.

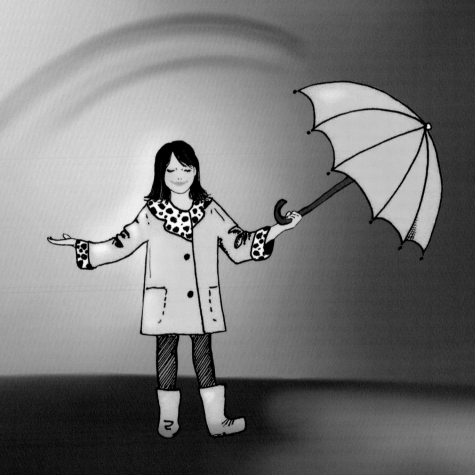

Is there any Remover of difficulties save God? Say: Praised be God!

He is God! All are His servants and all abide by His bidding!

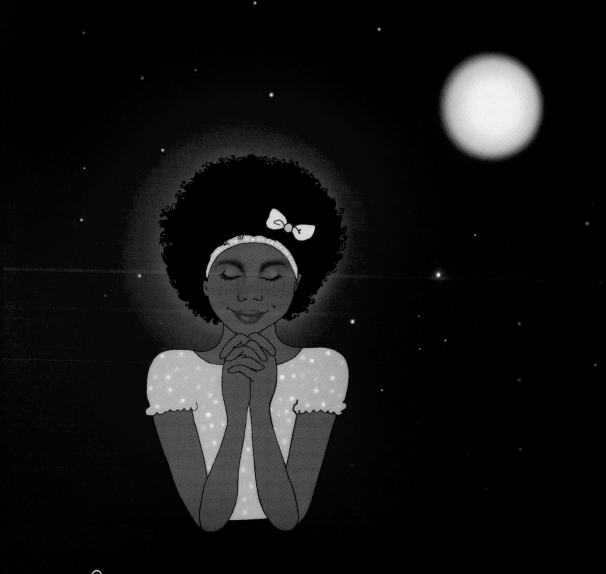

O God, guide me, protect me, make of me a shining lamp and a brilliant star. Thou art the Mighty and the Powerful.

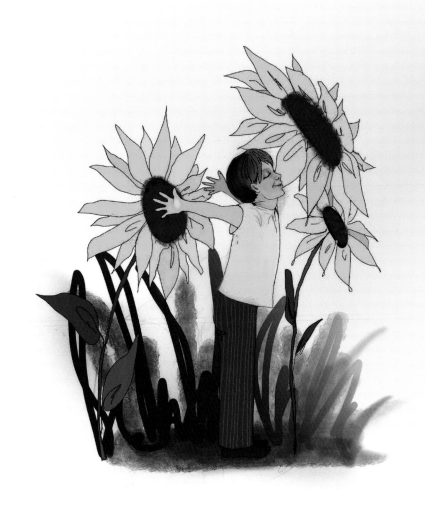

Love Me, that I may love thee.
If thou lovest Me not, My love can in no wise reach thee.

Never lose thy trust in God.

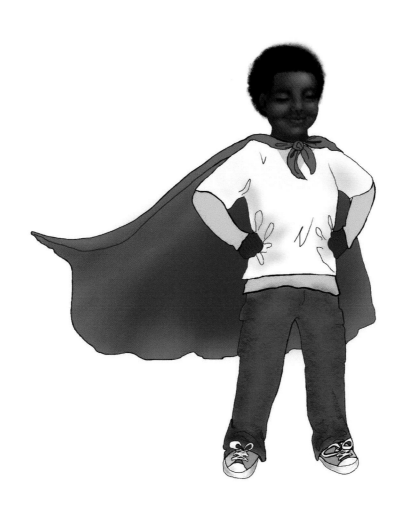

LET DEEDS, NOT WORDS, BE YOUR ADORNING.

HUMANITY IS

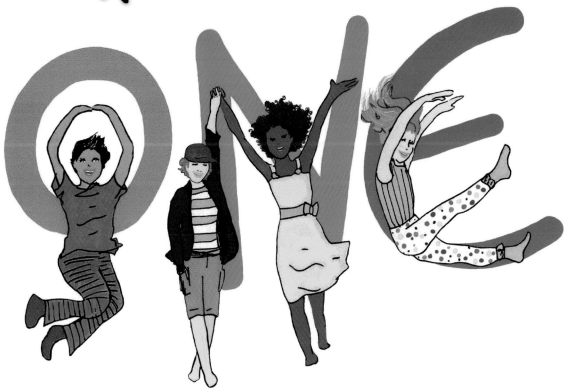

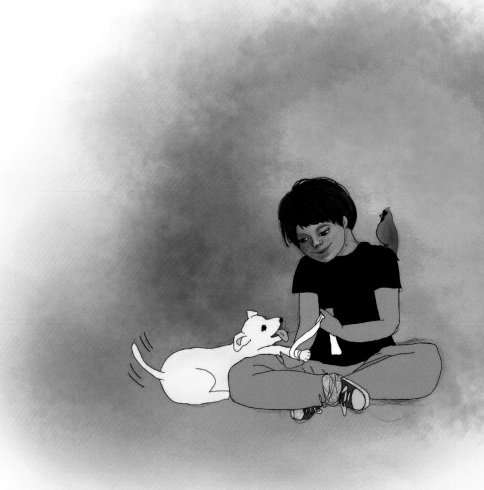

. . . show kindness to animals . . .

We are with you at all times,
and shall strengthen you through the power of truth.

REFERENCES

1. 'Abdu'l-Bahá, cited by Shoghi Effendi in "The Advent of Divine Justice", p. 26

2. Bahá'u'lláh, The Hidden Words, Persian #49

3. 'Abdu'l-Bahá, A Traveler's Narrative, p. 42

4. Bahá'u'lláh, The Hidden Words, Arabic #3

5. Bahá'u'lláh, The Hidden Words, Arabic #12

6. Bahá'u'lláh, The Hidden Words, Arabic #11

7. Bahá'u'lláh, Gleanings from the Writings of Bahá'u'lláh, p. 259

8. 'Abdu'l-Bahá, The Compilation of Compilations vol. II, p. 376

9. Bahá'u'lláh, Tablets of Bahá'u'lláh, p. 88

10. 'Abdu'l-Bahá, Paris Talks, p. 15

11. Bahá'u'lláh, cited by Shoghi Effendi in "The Advent of Divine Justice", p. 24

12. 'Abdu'l-Bahá, Paris Talks, p. 80

13. Bahá'u'lláh, The Hidden Words, Arabic #22

14. Bahá'u'lláh, Epistle to the Son of the Wolf, p. 14

15. 'Abdu'l-Bahá, Selections from the Writings of 'Abdu'l-Bahá, p. 27

16. Bahá'u'lláh, Prayers and Meditations by Bahá'u'lláh, p. 240-242

17. 'Abdu'l-Bahá, Paris Talks, p. 29

18. 'Abdu'l-Bahá, Paris Talks, p. 29

19. 'Abdu'l-Bahá, Paris Talks, p. 29

20. The Báb, Selections from the Writings of the Báb, p. 78

21. 'Abdu'l-Bahá, Paris Talks, p. 29

22. Bahá'u'lláh, Gleanings from the Writings of Bahá'u'lláh, p. 94

23. 'Abdu'l-Bahá, cited by Dr. J.E. Esslemont in "Bahá'u'lláh and the New Era", p. 71

24. Author unknown

25. Bahá'u'lláh, The Compilation of Compilations vol. I, p. 460

26. 'Abdu'l-Bahá, Bahá'í Prayers: A Selection of Prayers Revealed by Bahá'u'lláh, the Báb, and 'Abdu'l-Bahá, p. 37

27. 'Abdu'l-Bahá, Paris Talks, p. 109

28. The Báb, quoted by Shoghi Effendi in "The Dawn-Breakers", p. 30

29. 'Abdu'l-Bahá, Bahá'í Prayers: A Selection of Prayers Revealed by Bahá'u'lláh, the Báb, and 'Abdu'l-Bahá, p. 30

30. Bahá'u'lláh, Gleanings from the Writings of Bahá'u'lláh, p. 296

31. 'Abdu'l-Bahá, Bahá'í Prayers, p. 82

32. The Báb, Selections from the Writings of the Báb, p. 215

33. 'Abdu'l-Bahá, Bahá'í Prayers, p. 36

34. Bahá'u'lláh, The Hidden Words, Arabic #5

35. 'Abdu'l-Bahá, Selections From the Writings of 'Abdu'l-Bahá, p. 205-206

36. Bahá'u'lláh, The Hidden Words, Persian #5

37. 'Abdu'l-Bahá, The Promulgation of Universal Peace, p. 402-411

38. Bahá'u'lláh, Gleanings from the Writings of Bahá'u'lláh, p. 265

39. Bahá'u'lláh, Gleanings from the Writings of Bahá'u'lláh, p. 137

ACKNOWLEDGEMENTS

My deepest thanks to the following individuals, groups, and institutions for their generous financial support, who made the creation of this book possible:

Andrew Korab Amalia & David Smith Brian & Mojgan Solanti Didier
Bayan Rabbani R. Wilson Sheila Grant Dale & Randall Ricklefs
David Quinn Lua & Juliet Sobhani ALL Patrons on Patreon (2020)
116th US Congress & President Donald J. Trump (CARES Act)

Also, to my loved ones, friends, and collaborators who provided significant encouragement, support, and expertise toward the completion of this project:

Sabrina Laumer Rey Leal
Keri Marie Hill Annette Mercurio Carly El Kassaby
LeeAnn Leavitt Paul Collins Martha L. Schweitz Ann Levin
Stephen McInally Amanda Van Fleet & everyone at UBuildABook

In Memory of:
Nathan Reed-Stephen Mabrito

A portion of all profits from the sale of this book go to organizations working to protect and rescue children, that all may live happy and free to develop their highest capacity. Visit www.JacquelineClaireArt.com/book to learn more.

Bahá'í texts used with permission of the copyright holder, the National Spiritual Assembly of the Bahá'ís of the United States.

Published by *Jackie Ink*.

A subsidiary of Jacqueline Claire Art

www.JacquelineClaireArt.com

ISBN: 978-1-7357491-8-1

Made in U.S.A.

Supporting Small Business

ATTENTION: SCHOOLS AND BUSINESSES

This book is available at quantity discounts with bulk purchase for educational, business or sales promotional use.

For information, please send your query, including your institution and number of copies needed through:

www.JacquelineClaireArt.com/contact